The Editing of Star Wars

How Cutting Created a Classic

THE EDITING OF STAR WARS

HOW CUTTING CREATED A CLASSIC

LINTON DAVIES

ISBN: 978-1-4-716-7772-4

Cover Artwork: Prekesh Chavda
Cover Design: Prekesh Chavda, Tim Greenfield

Images from *Star Wars*, Lucasfilm LTD/Twentieth Century Fox Corporation.

Please direct all queries to Linton Davies, at lintondavies@gmail.com

Contents

Preface 7

Introduction 9

1 Rhythm 16

2 Parallel Action 35

3 Montage 40

4 Character Focus 48

5 Editor as Sceenwriter 53

6 Editing as Style 57

7 Conclusions 69

Notes 74

Bibliography 78

Electronic Sources 80

Filmography 82

Preface

My life is editing. It's my job, my hobby and the girl I come home to at the end of the day. It's a passion that shows me the world and then asks me to interpret it from a new perspective, that always has something new to offer and never strays far from my mind.

And what better way to analyse how editing really works, the effect it has and how this is created, than to look at one of the most beloved works in cinematic history? *Star Wars: A New Hope* (henceforth referred to simply by its original title of *Star Wars*) is 'my film', as it is for so many. Watching it for the first time on the eve of my 5th birthday, and then hundreds of times after that, undeniably changed my life. It is a film most cinephiles know well, and a perfect candidate to be analysed from the perspective of the cutting room.

The fact that for a film as beloved and often discussed as this, so little has been written in regard to its editing is telling. It

speaks volumes to the difficulties inherent in discussing a process whose meaning is not derived on screen so much as formulated in the minds of the audience, in the interpretation of images colliding against each other. This is why editing does not lend itself easily to criticism, and is what gives it its extraordinary power.

My goal is to demonstrate how 'cutting' is at the very heart of everything we love and remember about *Star Wars*, hiding in plain sight since its initial release. I believe there to be tremendous value in spending time thinking about editing in this way, not just from a purely theoretical perspective, but through the lens of a real-world example, where cuts take on a life of their own. Editing is ultimately and essentially the art of storytelling, so how can it be rationally discussed if separated from the story itself?

All that's left is to thank my Mum and Dad for inadvertently introducing me to *Star Wars* and to cinema, and for supporting me throughout my pursuit of this exceptionally silly career. Thanks also to Julie Lambden, who provided her endless patience and feedback throughout the editing of this very book.

Introduction

The impact of editing on a film often appears to be dismissed as almost incalculable, with little attempt ever made to quantify and examine its effects in a practical fashion. This is perhaps because editing requires such a special and particular attention to be paid to it in order to understand its workings. Whereas production design, cinematography or special effects jump out at the viewer, editing tends towards the opposite, giving rise to its reputation as the "invisible art" of cinema.

However, although at times general audiences see the craft as simply 'taking out the bad bits'[1], its importance is well accepted within the industry itself. Consistently the so-called masters of cinema, people such as Alfred Hitchcock[2], Stanley Kubrick[3] or Orson Welles[4], to name but a few, have expounded on how editing plays the most important role in the films they put their names to.

It is somewhat strange therefore that there is so little broader consensus or understanding of the topic in the public at large. Even people close to the industry often struggle to understand the creative potential of editing in its own right, with the Academy Award for

Best Film Editing consistently simply following the Award for Best Picture.

Welles discusses editing as "a kind of musical instrument, one where other film instruments are tuned and finally orchestrated together" [5] and this lies at the heart of the difficulty. Editing is a reactionary medium, one where decisions depend entirely on what's being interacted with, as the editor tries to get the most out of the creative possibilities held within the material at his or her disposal. It is harder therefore to describe and quantify what makes editing 'good' or 'bad' in general terms than it is for an art form where something is created out of nothing.

Put simply, if a film's script, acting and cinematography are of poor quality, it is difficult to separate the work of the editor from these negative attributes. Ironically, it can often be when things have gone wrong that editing by necessity becomes most inventive, attempting to salvage something positive from the wreckage that has come before it. It is also a common occurrence that an editor must sacrifice a cut which may work best for pace or rhythm, qualities seen to be at the heart of the form, in order to improve a performance or avoid a badly-composed shot. Here an editor paradoxically sacrifices the 'editing' of the film in order for it to ultimately be 'better edited'.

Despite these difficulties, it would be unfair to say that substantial work has not been done to advance editing theory. From Eisenstein and Murch to Pudovkin and Dymytryk, much has indeed been written on the subject, but study has tended to focus on broad concepts such as Murch's famous list of cutting criteria[6], or Dmytryk's 'Seven Rules of Cutting'[7], rather than on a discussion of individual works.

A different kind of analysis can perhaps offer an alternative perspective on the work of an editor; how impact may be achieved through the manipulation of the craft.

The editor's job is, in the simplest of terms, to mould the shot footage into the strongest possible film, and each splice works towards this goal. The effect of a cut is derived less from the craft of editing itself than from the film it pertains to, and the correct decision (if such a thing exists) can only be determined by examining the two shots being joined together, as well as their position both within the sequence and the film as a whole. In addition, auxiliary issues such as the production's target audience and the contemporary sociological context must also be taken into account. These decisions simply cannot be made in the abstract, therefore a close examination of the editing entirely within a particular film may perhaps shed light on how they come to be made in a way which broader analysis cannot.

This should offer a better overview of the different types of work and decision making an editor puts into a film, and will help emphasise the extent to which post-production ultimately plays a role in the final product.

The film under discussion is *Star Wars*, released in 1977[8], directed by George Lucas and edited by Paul Hirsch. The film is one of the most successful ever made in terms of lasting cultural impact, with Roger Ebert commenting: "all the big studios have been trying to make another *Star Wars* ever since; it relocated Hollywood's centre of intellectual and emotional gravity"[9].

When adjusted for inflation it remains the second highest grossing film of all time[10], behind only *Gone with The Wind* (1939, dir. Victor Fleming), and it influenced an entire generation of filmmakers. James Cameron, David Fincher, Christopher Nolan and Ridley Scott, to name but a few, have all described watching *Star Wars* as a formative experience in shaping their careers[11]; it truly had an enormous impact in shaping the modern film industry as we know it today.

It is this mainstream appeal and longevity that makes *Star Wars* particularly useful in the context of this type of analysis. The film and its editing techniques conform very much to conventions of so much of Hollywood cinema, and therefore hint at broader conclusions that can be applied to much of the industry[12]. This is in contrast to films that are more commonly remembered for their

editing, such as *Memento* (2000, dir. Christopher Nolan) or *À Bout de Souffle* (1960, dir. Jean-Luc Godard), which stand out precisely for being radically 'different' or unconventional in their cutting.

There are several caveats though, to such a discussion, ones that have perhaps deterred others from embarking on similar types of analysis. The first is that editing is so inseparably linked to the other crafts of filmmaking, from acting to art direction, all of which contribute to how a film comes into being. In its essence, editing is the telling of the story in the most efficient and engaging way possible, the final rewrite of the script as it were, and as such it is difficult to extract what were specifically editing decisions, and which were enforced by the shooting draft and its interpretation by the rest of the crew.

In addition, any such discussion is limited by not having access to the full body of rushes. It is not possible to judge what footage has been left out, or whether technical or creative faults had to be worked around. However, the enduring popularity of *Star Wars* is a useful asset in this regard. Countless reflective pieces by cast, crew and fans give insights into all areas of production and how the film came to be created. These will henceforth be used on occasion as source material for identifying the extent to which editing played a part in particular decisions. However, where such information is unavailable, only basic coverage will be presumed to have been

obtained for each scene, the minimum requirement for any large production of this type.

The discussion will centre around an attempt to extract editing as much as possible from the rest of the film, focusing on how effectively it enhances and reinforces the narrative in its own right.

Finally, George Lucas described the underlying goal of *Star Wars* by saying that it should be "fun, exciting and inspirational, people respond to that, it's what they want" [13]. An analysis of the film's editing will be framed within this context, looking at how cutting is used to enhance and draw out these emotions to the greatest extent possible.

It should be kept in mind that although editing is conceived in the cutting room, its creator is *not* only the editor himself/herself, with ideas drawn from the input of directors, producers and studio executives amongst many others. This is complicated further in the case of *Star Wars*, where three people, Paul Hirsch, Richard Chew and Marsha Lucas all hold an editing credit. It is Hirsch though that is known to have played the key role, notably fine-cutting the film alone for the final five months of post-production[14]. For the sake of brevity he will to a great extent be referred to as the decision maker, in the same way as a director's name tends to be used symbolically in more general cinematic analysis.

Editing is of course the sum of many thousands of decisions, with *Stars Wars* composed of 2177 cuts[15], and hundreds more hours worth of footage discarded along the way. It is necessary therefore to centre the discussion around several core areas: rhythm, montage and parallel action, as well as the way editing is used to enhance character, narrative and style. These represent the areas where editing tends to be both most apparent and most influential within a typical feature film, and they provide a useful framework to focus in on.

Rhythm

The construction of rhythm is perhaps the most creatively powerful aspect of film editing, in that it is where the editor's work most directly and uniquely shapes the viewer's experience[16]. Interestingly, it is also the area where editors struggle most to verbalise the rationale behind their work, discussing the application of rhythm as being within the realm of their subconscious mind. "We go by intuition" states Alan Heim (ed. Network) firmly[17], "you just know", remarks Sidney Levin (ed. *Mean Streets*)[18].

The function of rhythm can be described as being to create a sense of 'flow' across a film. This flow is the embodiment of cycles of tension and release (faster or slower rhythm) which affect the viewer physiologically, emotionally and cognitively[19]. It is the manipulation of these cycles that maximises our involvement with the film, but there is little consensus on how this can be achieved, beyond the subjective test of it 'feeling right'. Academically, rhythm is viewed as an area of great complexity, one not yet fully understood[20]. Practical decisions in this regard are based more on

instinct and personal preference, with editors calling on their experience to act as a surrogate for the audience, sensing where and when cuts should be made.

When discussing rhythm, Hirsch describes himself as "the conductor of the piece", keeping the pace up to where he thinks it should be, judging when the tempo is too fast or too slow[21]. It is of upmost importance he says, to dictate the rhythm of the film, warning actors to "pause at your own risk"[22]. It's telling that Richard Chew, who cut sections of the film with Hirsch, described working on the rhythm of *Star Wars* as their main task when putting the film together:

> "When me, Paul (Hirsch) and Marsha (Lucas) arrived it was cut in a very traditional manner, just playing things out in masters and then going into coverage, letting the actors' rhythms dictate the cuts rather than having the cuts drive the rhythm of the scenes[23]."

Unsurprisingly, the variation of shot durations is the principal tool at an editor's disposal when shaping rhythm. Quicker cuts serve to increase tension in the audience, creating stressed and accented moments of action[24], often motivated by an action sequence or an emotional confrontation. As such the average shot length (ASL) of a film will tend to increase rapidly during the last act, as the plot draws to its conclusion. Films with a large amount of

action will tend to have a lower ASL than works from other genres, for instance *The Bourne Supremacy* (2004, dir. Paul Greengrass) has an ASL of just 2.2 seconds, compared with the 5.6 second ASL of *21 Grams* (2003 dir. Alejandro Gonzalez Inarritu).

The psychology behind this is relatively simple: by controlling rhythm through shot durations the editor controls the amount of time the viewer has to think about and reflect on what they're watching. As such, quicker cuts ask the audience to perceive things at a faster pace. This increases their involvement in the action and forces them to make all or nothing yes/no decisions on what's in front of them. We are no longer able to anticipate what will come next; everything becomes more surprising and dramatic. This was famously first explored by D.W. Griffith in *Intolerance* (1916), with the pacing of the film's many different story-strands gradually quickening as the film progresses.

Crucially though, the barometer for the 'speed' of a cut in this discussion is not formed in comparison to a general scale, but rather as compared to the general rhythmic tendency of the rest of the film. The feeling that can be derived from quick cutting is not purely a result of the duration of the shots in and of themselves, but rather of the changing flow of the rhythm, with calmer sequences serving to intensify the excitement of quicker ones. As Rudolf von

Laban summarises, "rhythm is not just a duration of time, it is the result of the interaction of combinations" [25].

A sequence of five second shots will most likely feel markedly slow if it comes after a prolonged action sequence, where shots tended to last mere fractions of a second, but conversely would appear to be a dramatic increase in tempo if the rest of the film is comprised of thirty second clips.

Just as accelerated rhythmic editing can emphasise a climax, it also helps create a type of narrative climax of its own. A quickly cut sequence increases the perceived significance of what happens on screen, not least because it paradoxically tends to increase the overall duration of the sequence by repeating various actions from a number of different angles and perspectives [26]. This is the case in Star Wars when the rebels overrun the prison block in a quick-fire gun battle. The scene is cut extremely rapidly, with a two second ASL, and the action it covers is brief: the rebels simply shoot down the guards and the security cameras. However the extremely quick editing creates a feeling of confusion and disorientation, and Hirsch is thus able to use shots of the same pieces of action occurring from multiple angles, subtly increasing the dramatic effect of the scene. In fact the same shot of a camera being smashed is used three times in fifteen seconds, but the frantic pace of the scene means that the repetition goes unnoticed by the viewer. This is a turning point in the film, and the chaotic editing style reflects this feeling.

Arguably the best way to explore and better understand rhythmic editing is by counting and examining the positions of the cuts directly, in order to acquire a less abstract perspective of how rhythm is constructed across a film. However this method too has its limitations. Although editors use durations to affect a film's rhythms, such choices function alongside or in response to the rhythm already inherent in the material. These come from the movement in the actors' performances, the camera's positioning, the mise-en-scène and the rhythm of the sound. That as well as 'tonal movement', which is reflective of what's going on within the context of the story.

Such disparate elements of course cannot be quantified or accounted for by an examination of shot duration alone. The flashing of a neon sign or the acceleration of a car chase each has strong visual beats in and of themselves[27], all of which have a significant affect on the film's flow. While the duration of the cuts generates an *external* rhythm, created by the editor, the *internal* rhythm created by these other factors is also relevant and should not be forgotten[28]. Eisenstein indirectly warns of this when discussing metric montage, explaining that forcibly applying durations to shots without regard for their content will result in "montage failure". He describes the different elements within shots as "attractions" [29] the more attractions there are he says, the more the shot will focus the audience's attention. The denser a sequence with these elements, the quicker the rhythm will feel.

Reisz and Millar make a similar point, asserting that the "story of each shot" [30] will take varying amounts of time to unfold.

However, as David Bordwell suggests in *Counting the Cuts*, the number of frames per shot does still give a strong sense of a film's rhythmic variations, and contributes considerably to what we recognise rhythm to be[31]. The amount of cuts should be viewed as an indicator rather than a pure aesthetic in and of itself, and in many cases cutting is used in tandem with the tempo already inherent in the material. Thus, although cut counting should not be viewed as the be all and end all, it is probably the most effective way of objectively analysing editing in a manner which is useful.

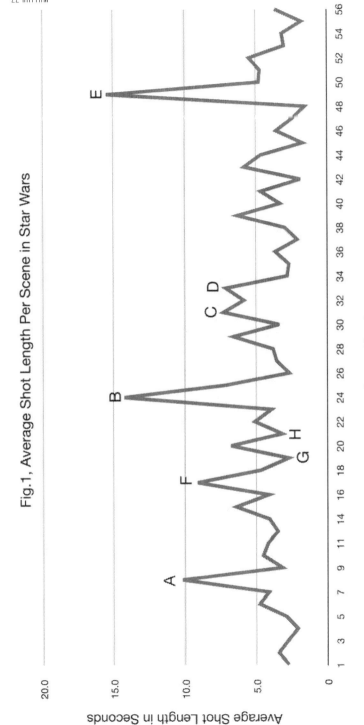

Fig.1, Average Shot Length Per Scene in Star Wars

Fig.1 is a graph of the average shot lengths of each *Star Wars* scene, an analysis of which immediately brings a striking pattern to the fore. Across the film Hirsch uses two separate patterns of rhythm concurrently, one for the primary story strand of Luke joining the rebellion and rescuing the princess and then another clearly distinct and different pacing for the scenes focusing on the Empire and Darth Vader, as they attempt to crush all that stand in their way.

Following the separation of the two strands in the opening sequence there are five scenes focused on the Empire alone, occurring in parallel to Luke's quest. Compared to the rest of the film these scenes (A, B, C, D, E) are cut exceptionally slowly, with only one scene from the rest of the film, (F) with an ASL anywhere near as high. These distinct cutting styles help emphasise the differences between the separate camps, and re-enforce the different tones and atmospheres of each. This creates a steady flow, with the pacing of the film moving steadily up and down as Hirsch cross-cuts between the two camps throughout the first and second act.

Hirsch is using the rhythm in his cutting to enhance a narrative element, the contrast between the two sides. The slower scenes help sustain the impression that the Empire is in complete command, exerting cold and calculated control over the galaxy. Cutting patterns in these sequences feel precise and clearly structured; for instance the boardroom scene, where Tarkin

announces the dissolution of the Senate, is composed of a symmetrical shot/reverse shot structure and a sustained fluid dolly move around the table.

The editing here feels very much in keeping with the personality of the Empire, as well as with the polished reflective surfaces that make up the production design, inspired as they are by Jean-Luc Godard's *Alphaville* (1965)[32].

This slower pace then serves to underscore the more kinetic and frantic feeling of the quicker cutting within the principal story structure, with the rebels working chaotically and danger around every corner. While the boardroom sequence has an ASL of 14 seconds, and is composed entirely of four steady and carefully composed angles, a scene of equivalent length involving the rebels, when R2D2 is captured by the Jawas, has an ASL of 3.2 seconds and is made up of eighteen different camera positions. Furthermore, here compositions constantly shift between handheld and tripod shots as well as point-of-view and observational angles.

Interestingly, although Bordwell describes a principal motivation for fast cutting as being for "scenes of tense emotional confrontation" [33], by far the most emotive sequence of the primary story strand is also the one which is cut the slowest. This is a key turning point of the film, where Luke returns home to discover the death of his aunt and uncle (F), and has an ASL of 220 frames. Shots

last a full 2.5 seconds longer here than in any other scene involving Luke or the rebels.

While faster cutting can indeed be used for emotive purposes, It tends more to be in the service of generating excitement and intrigue than feelings of tragedy, loss or grief, something Bordwell is wrong to ignore.

Other examples of similar scenes, such as Gandalf's death in *Lord of The Rings: The Two Towers* (2002, dir. Peter Jackson), or Tom Hanks's final goodbye to Jenny in *Forest Gump* (1994, dir. Robert Zemeckis), unsurprisingly suggest a similar pattern, with scenes of intense personal emotion lingering longer on elements that compose the sequence (most commonly reaction shots of central or surrounding characters). This gives the audience more time to digest what has taken place.

The ability of the audience to complete this kind of 'tonal gesture', to experience a feeling such as grief or sadness in these scenes, is very context sensitive. The viewer is far more likely to pick up the narrative's intended message if they are not too quickly confronted with fresh information, such as a jolted opening to the scene that follows[34].

In these situations the purpose of the scene is not so much to divulge *explicit* information but rather to evoke *implicit* feeling and sentiment. As such the editor slows the cutting speed and the

divulgence of fresh visual stimuli in order to allow the audience time to go through that process.

It's telling that the scene following the grieving sequence in *Star Wars*, in which Leia is tortured for information by the Empire, was in fact originally intended to be placed much earlier in the film, but was moved directly after this critical turning point for both rhythmic and emotive reasons[35]. The viewer's feelings of compassion for Luke following the death of his family now morph into hatred and anger at the Empire, as we see the extent of their violence and malice. We consequently empathise and align ourselves yet further with Luke, experiencing the same emotional journey, uncovering the full horror of the Empire as he does. This moment will go on to propel both Luke and the audience forward throughout the rest of the film.

The Lea torture scene was also recut to be much quicker during the final weeks of editing, breaking with the style of the other Death Star scenes (A, B, C, D, E), which otherwise maintain their secondary rhythm consistently throughout. This has the effect of picking up the audience after the dramatic sequence that preceded it, and compounds the tyranny and threat of the Empire. It is telling that here the rhythm of the primary story-strand has been broken, slowed down to appropriately pace the death of Luke's relatives, and Hirsch immediately reacts by temporarily changing that of the secondary storyline to compensate. The slowest sequence of Luke's strand is

followed directly by the quickest of Vadar's, both are outliers on their respective rhythmic curves. Hirsch sets out a rhythmic pattern in order to achieve narrative and tonal goals - differentiating the two sides - but he is quite happy to sacrifice it for the overall pace of the film if and when required.

The control and stark variation of pace is a hallmark of Hirsch's editing in *Star Wars*. As the heavy variations on the graph demonstrate, slower and quicker scenes are alternated remarkably consistently, with Hirsch orienting the audience in such a way as to maximise their engagement. This serves to add punctuation to the high intensity moments and creates a strong sense of tempo across the film.

Longer scenes of quicker rhythm such as the Cantina sequence are followed by slower, often single shot scenes of parallel action from elsewhere. The Cantina scene is made up of two sections, with an average of 66 and 77 frames per cut (scenes G and H respectively), intersected by a single shot sequence of the droids waiting anxiously outside.

This relative pacing can be anticipatory as well as reactionary, for instance the final climax, a sustained high intensity twelve minute sequence (44 ASL), is preceded by three markedly slower scenes (116, 114, 132 ASL). Here the plans are slowly

downloaded from R2D2, then analysed by the rebel commanders,
before finally everyone says their goodbyes and prepare for battle.

The sense of anticipation, of impending climax, is
emphasised by the overall rhythmic arc that runs across the film.
After the opening battle sequence, where the two opposing sides
separate, the pacing gradually and almost imperceptibly quickens as
the film drives towards its inevitable climax. The first act has an
ASL of 90 frames per cut, the second of 79 and the third of 55.75.

This gradual change, like many of the choices discussed in
this section, will obviously be unnoticeable to the viewer, but creates
a subconscious sense of build up and anticipation. The pattern lies at
the foundation of the way in which the story is told; it is the
backbone for every sequence, every scene and every cut.

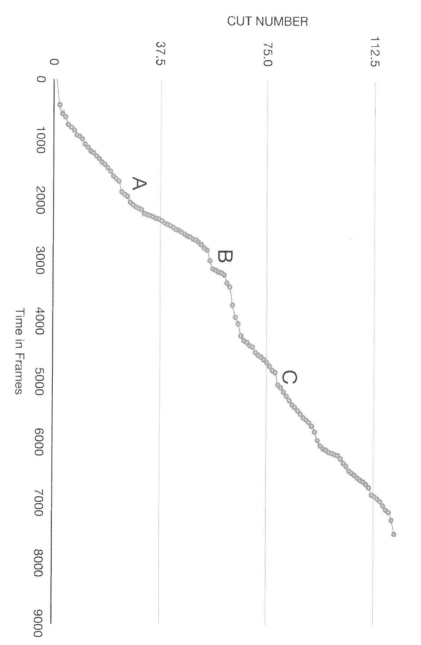

Fig.2, Shot Lengths in Star Wars, Scene One

The replication of these patterns is equally discernible across individual sequences; Fig.2 graphs the number of cuts across the film's opening sequence, as the Empire overcomes the rebel ship. It serves to demonstrate the extent to which Hirsch uses the same techniques on every level of story-structuring, with a single scene composed of several complete cycles of tension and release. This sequence of high octane action encompasses much of what *Star Wars* is about, the feeling of excitement that Lucas alludes to, and it has editing style as its foundation.

The periods of fast cutting are punctuated by slower segments (Fig.2 A, B, C), described by Hirsch as "periods on a sentence" [36], just as faster scenes are broken up by several that are slower paced across the film as a whole. This helps build an urgency in fitting with the intended tone as the rebel ship is rapidly overrun.

Point A is one such instance; the shot comes between two phases of action: the frantic preparation of the rebel troops and the even more frantic battle sequence. Both of these sections are 'tense', the audience drawn into the action and the film through a montage of chaos, gunshots and disorientation. Cuts come thick and fast, with shots rarely lasting more than two seconds. However, between these two sections is a slow, six second shot of the two ships finally coming into contact with one another. This serves as the end of one cycle of tension, the frantic preparation for battle, as the action slows and the audience calms down, before building up again to the even more dramatic shootout itself.

By establishing a tempo, and then so drastically breaking
with it, here Hirsch succeeds in initialising a cognitive thought
process in the audience. The shift in rhythm tells the viewer that
something is about to happen, and the long shot suggests a build up
to an even more frenzied climax than the initial period of quick
cutting. This all adds to the mounting tension and anticipation,
making the eventual release of that energy when the battle begins all
the more satisfying.

The opening confrontation between rebels and
stormtroopers also serves to demonstrate what Bordwell means
when he contends that fast-cutting will often *increase* the total
running time of a sequence, with editors repeating actions in order to
give the audience a richer sense of the unfolding drama. Here Hirsch
allows two rebel fighters to die twice in consecutive shots; this is
unnoticeable given the duration of the cuts, but adds to the feeling of
confusion and massacre. In addition, Hirsch also uses this technique
during the preparatory sequence to increase the audience's
involvement, both with the characters and the situation, by cutting
together multiple reaction shots in quick succession. Thus, although
the speed of the cuts has been quickened, the actual screen time of
the sequence increases, with the same moment in time played out
from multiple perspectives. Cutting the sequence in this manner
serves to give the moment a de facto significance[37].

Soldier A dies at 03.50

Then again from behind, at 03.58

Soldier B first dies at 03.55

Then again in close-up at 03.59

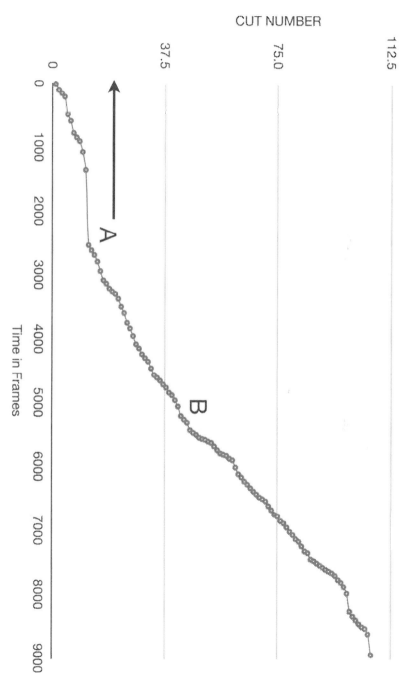

Fig.3, Shot lengths in Star Wars: The Phantom Menace, Scene One

A useful comparison can be made to cutting patterns in the opening of *Star Wars: The Phantom Menace* (2001, George Lucas) (Fig. 3) The film, also directed by Lucas, covers remarkably similar story arcs, but was largely perceived as a disappointment[38], not least in terms of its editing[39].

In contrast to *Star Wars*, *Star Wars: The Phantom Menace* begins comparatively slowly (Fig.3 up to point A), and remains largely consistent in terms of its pacing. The cuts slowly build up until the first battle begins (B) and then continue at a fairly consistent pace. Although the editing would have been considered relatively 'quick' in comparison to other films of the time, the sequence lacks flows of tension and release; there is little sense of dramatic escalation. This leaves the scene feeling flat[40] when compared to sequences in the 1977 film, with editor Paul Martin-Smith failing to use rhythm to its full potential.

Parallel Action

As the discussion of rhythm has indicated, cross-cutting between locations can play a big part in how editors control the telling of the story, both in terms of pacing and narrative. This parallel action technique, where separate storylines unfold in tandem and the editor goes back and forth between the different locations ('meanwhile'), is a powerful way of maintaining interest in both sides of the story, and heightens the excitement when the separate strands inevitably collide.

Editors rework and rearrange the unfolding of events in order to maximise the narrative's potential, moving scenes around for the purpose of creating the most engaging 'flow' of information. This is one of the most effective techniques for accommodating issues that are simply impossible to predict until the film has been assembled.

Anthony Harvey, editor of *Dr.Strangelove* (1974, dir. Stanley Kubrick), for instance described Kubrick's script as "the most brilliant and perfectly constructed" he'd ever read, and yet he says, they were *still* required to delay and change the ordering of the

scenes in order to "gain clarity and sustain interest", because "the tension didn't develop properly" [41].

Eisenstein describes the purpose of cross cutting as simply to avoid boredom, to move away from one set of characters and scenarios when the audience begins to tire of it. Pudovkin meanwhile contends that parallel action should be viewed as a more complex technique, one that if used correctly can "really excite the spectator" [42]. He describes the question of when to go between the storylines as understanding precisely when the audience is about to ask "what's happening over there", and cutting just before they do so. If at that moment the audience is moved to that location, the film will become infinitely more satisfying as a result.

Parallel action also allows editors to emphasise contrast, whereby two characters or situations can be thrown together and the audience asked to observe and interpret the differences between them, in a similar way to its use in traditional Soviet montage.

The parallel action used in *Star Wars* is very much that of 'the pursuers and the pursued', with the audience able to follow the chase between the rebels and the Empire despite them being galaxies apart. Continually cutting back to the Imperial forces also serves to maintain a sense of threat and urgency throughout the film. This adds some much needed drama and purpose to sequences such as the Cantina scene, which otherwise were in danger of appearing simply

as an excuse to show off the myriad of creatures Lucas had created; a sense that many of the subsequent films in the franchise suffer from.

The crux of the story is ultimately Luke's journey and coming-of-age as he learns the ways of the force, but this is given relevancy and importance by maintaining the secondary storyline of the Empire on his tail. This shows the viewer what's at stake, why what he's doing matters, and consequently deepens our emotional investment in his success.

The relatively separate nature of the storylines gives Hirsch flexibility as to when he changes axis and which part of each story he uses when, allowing him to use parallel action to its maximum potential.

For instance, he decided to move the scene of the Imperial forces discovering the droids' tracks considerably earlier than originally intended in order to introduce the threat of the chase as soon as possible. It is in this short scene that the audience learns that the droids have not in fact completely escaped the clutches of the Empire. This reignites the element of danger and threat to the central characters; they may not realise it yet but they're being followed.

By moving this scene forward, the subtext of the three that follow (originally intended to come beforehand), where Luke buys the droids, cleans them up and argues with his relatives, changes dramatically. While this section may otherwise have subdued the

pacing and tone of the film somewhat, being particularly dialogue and back-story driven, it is now infused with a sense of urgency. By introducing the parallel action of the stormtroopers searching for the droids, these scenes with Luke now feel more relevant in relation to the battle sequence that has come before. The editing decisions have subtly moved the worlds closer together, and in doing so sets them on a collision course that the audience foresees and anticipates.

Leia's capture in the opening scene was also moved to play out earlier than scripted, now coming ahead of the droids departing in the escape pod. This is an example of cross-cutting being used for thematic purposes, to create a contrast between Leia, the innocent princess dressed in white, and the dark terror of Darth Vadar, who in the previous scene has just tortured and killed a member of the rebel fleet.

This exposes another use for this kind of cross-cutting, that of contrasting and connecting two separate elements within the consciousness of the viewer, something Pudovkin sees as the most powerful, if often overused, editing technique[43]. Through the constantly developing parallel action Hirsch again and again emphasises the differences between the Rebel Alliance and the Empire, juxtaposing the two sides whose attitudes, status and mise-en-scène could not be more different.

This helps create a very clear distinction between heroes and villains, one which is emphasised through the variations between

tight and loose cutting styles. It's telling that when the two sides converge, with the rebels infiltrating the Death Star and saving the princess, a third editing pattern emerges. The apex of this comes with the attack on the cell block, with the scene cut up into disorienting fragments, close-ups and diverse angles that discard the so called 'laws of editing' such as the preservation of spatial continuity and the 180 degree rule. The effect is simply chaos and confusion, with the audience no longer able to follow what's going on. This is precisely what both the film's editing and plot had implied would occur, and helps express the sense that the order of the galaxy has broken down.

Significantly, when the climactic final battle begins, the different styles which have denominated each side have now effectively been reversed. The rebels are portrayed in static close ups, and appear a mostly efficient and coordinated unit. Wedge's comment "look at the size of that thing!" is greeted with an icy "cut the chatter Red Two" [44] while inside the Death Star there is now chaos and disorder. The camera shakes with the impact of each explosion and Hirsch jump cuts sequences of stormtroopers running aimlessly, just as he had previously done with rebel forces in the opening scene.

Montage

Montage is often seen to be where editors are most free to be creative, to ignore certain laws of continuity in order to prioritise feeling and emotion. It thus allows for more flexibility in creative choices, with Eisenstein describing it as "a special form of film speech"[45].

In these sequences the meaning of what is shown is constructed not simply by what's represented on screen, but by the manner in which it is fragmented through editing; its message is devised to a certain extent outside of the film's narrative. This is what led neorealist André Bazin to oppose montage, denouncing it for constructing meaning that in his view was not present in the original footage, intentionally deceiving the audience[46]. This power was perhaps most succinctly encapsulated by the so called 'Kuleshov Effect'[47], an experiment in which the image of a man's stare was cut against various objects, and his expression was seen by the test audience to reflect different emotions depending on what editing implied he was looking at. The Kuleshov Effect was directly

and knowingly reproduced in *Star Wars*, when Luke returns home to find the burning corpses of his aunt and uncle. Mark Hamill felt he should fall to his knees and cry, however Lucas, a keen student of editing[10], insisted on a restrained performance, conjuring the feeling of grief in the audience by cutting from Hamill's blank stare to the point-of-view shot of the fire[49].

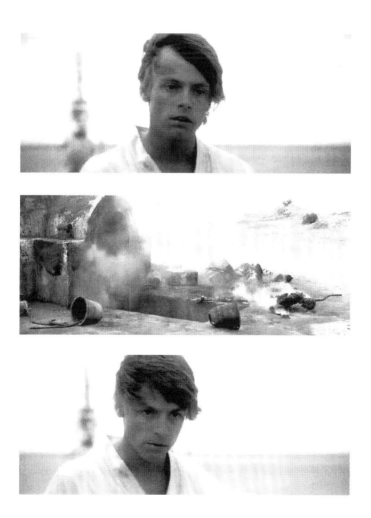

There is though some confusion and disagreement over what exactly the term 'montage'; designates. In French cinematic vocabulary 'montage' simply means editing itself, while in Hollywood a 'montage' tends to be viewed as a sequence in which narrative information is presented in a condensed timeframe, often set to music. The word originates though from Soviet cinema, where montage described sequences of editing where meaning was created through the editing itself, not simply from the action in each shot[50].

However, as the craft of editing has developed, it would be fair to suggest that the lines between standard editing and montage, both within the Soviet and Hollywood definitions, have blurred. Editing constantly creates additional layers of meaning through the collision of different shots; two well placed close-ups of people staring at each other will create a sense of tension present in neither of the shots themselves, but would not generally be considered as montage.

In addition, editing is always concerned with the condensing of time; the action of a film generally takes place over a series of days but unfolds in around an hour and a half. In this sense every film can be considered a type of montage.

The cutting back and forth between the rebels and the Empire in the first half of *Star Wars* both condenses time (each side's timeline will have jumped forward considerably when returned to) and creates meaning by juxtaposing and contrasting the two camps, as well as developing the sense of one side chasing the other.

Perhaps then this too should be considered a form of montage. Godard is open to this broad type of interpretation, stating "knowing just how long one can make a scene last is montage in itself" [51].

Ultimately this perhaps speaks to a perceived divide between 'practical' and 'creative' editing. Editors are in actuality constantly condensing time and creating meaning through their work, thus montage appears to simply delineate sequences of cutting where this is most clearly foregrounded to the audience, where it is noticeable simply by watching the film rather than by analysing it.

The final climactic sequence is a useful practical example of just how powerful montage, by any definition, can be in effecting how films are both told and experienced. In *Star Wars: Deleted Magic* (2009) Garrett Gilchrist re-edits this sequence to proceed in the order originally laid out in the script; differences between this and the final version provide an interesting demonstration of the work Hirsch did to change and improve the final product.

A key narrative device the film uses to create excitement in this sequence is the lowering countdown, telling the audience how much time remains for the rebels to carry out their attack before their base is in firing range of the Death Star. Hirsch creates tension and suspense by constantly reminding the audience of this threat, often following it with a shot of Princess Leia in the rebel control room, reinforcing the fact that her life is at stake. This is a technique he admits to being fond of: "if somebody's tied to a track, it's boring

unless there's a train coming! you can't create suspense without telling that to an audience" [52]

The sequence also includes classic Eisensteinian methods of montage, where a shot of a Death Star cannon being fired is followed by green sparks appearing across the sky, followed by a shot of a rebel fighter turning. We never see the gun shot hit or miss the fighter, but the editing infers to the audience that it was not successful.

Perhaps the most famous instance of this kind of pattern occurs earlier though, in the Cantina sequence when a shot of a swinging lightsaber cuts to a bloody arm on the ground. The audience is never shown the moment of gruesome impact, but is clearly able to infer what has taken place through this montage technique.

Comparing the version of the climax as scripted to the final cut as it appears in the film, the most important change made in the cutting room lies in the emphasis on the characters and locations not directly involved in the battle itself, but affected by its result. At every opportunity Hirsch cuts away from the battle to focus on Tarkin, Vadar or Princess Leia. This demonstrates an astute understanding that what makes the sequence engaging isn't so much seeing the fighters evade or get hit by gunshots as it is the resultant effects these actions have on both sides of the battle, on characters we have come to love and hate.

For instance, whenever the rebels sustain a hit or a casualty, Hirsch will invariably cut to a reaction shot of Leia looking concerned about what's happened, and then from her to a shot of Tarkin confidently pondering the Empire's next move. This has the effect of deepening the emotional impact of the event for the viewer by experiencing it from Leia's perspective, a character we already know and empathise with. Then, by subsequently cutting to Tarkin the Empire is further demonised, as he does not show the compassion that both the audience and Leia are feeling; his calm persona implicitly increases the jeopardy we feel our heroes are in.

This three shot pattern is repeated five times throughout the sequence and is an excellent example of montage editing combining images to create an impression far greater than the sum of its individual parts.

The final moments of this sequence best encapsulate the power of this kind of cutting[53]. In the scripted version Luke simply fires the proton torpedo into the Death Star and flies away as it explodes. However in the finished film, after the shot is fired Hirsch first cuts to Leia again, leading the audience to question whether they were too late to save her, and then to Tarkin just before the explosion erupts.

This moment becomes infinitely more powerful for the addition of these shots, which add nothing to the narrative action, but give the audience a reason to cheer; both because the rebels have survived and because their tormentor has been destroyed.

Character Focus

Audiences tend to forget just how much footage is shot during the making of a film, how every character at any point in a scene has been covered from a vast variety of angles. The choices of which of these shots are used and when are crucial to the shaping of the narrative, and are decisions made entirely in the cutting room.

The most interesting and important of these decisions lies in which character to focus on at any given moment, something which will define the dramatic focus of the scene[54], and ultimately who and what the film is about. If choices in this regard are poor or inconsistent, the film will inevitably feel disjointed and will frustrate the audience.

Whereas the choice of cutting to an insert when something is written down, or to an object when it is looked at are somewhat rudimentary decisions, ones that could perhaps be described as 'craft editing', choices that concern emphasising certain characters over others lie at the very heart of a film's narrative. The close-up in particular represents a form of narrative construction, where the

camera orients the viewer's attention to focus uniquely on whoever is deemed of upmost importance at any given point in time[55].

Before Michael Corleone kills Virgil Sollozzo in *The Godfather*'s famous restaurant scene (1972, dir. Francis Ford Coppola), editor William Reynolds holds on his close-up shot for a full thirty seconds before the gun is fired, completely focusing the audience on his emotional state while the conversation around the table continues unnoticed.

Conversely, the decision not to focus on a character can be equally powerful; Charles Foster Kane is never shown to the audience in the opening scene of *Citizen Kane* (1941, dir. Orson Welles), despite the fact that the sequence specifically depicts the final moments of his life.

In *Star* Wars, the decision to emphasise the characters of the two droids, C3PO and R2D2, was a particularly brave one and is emphasised and cemented through editing. Hirsch returns to these characters consistently in every scene they're involved in, and is careful to allow screen time to set up their traits and conventions. This is an example of a bold idea, practically unheard of within the context of Hollywood cinema at the time, that is supported and followed through by editing choices.

The droids are used very much as a framing device, they're the audience's perspective within the film[56], and we relate in particular to C3PO's bemusement as to what's going on; the world

seems as alien to him as it does to us. Like the audience, he has little understanding of the broader conflict that surrounds him, or of his own position within it[57]. His constant fear and confusion mirrors what we would feel in the same situation, putting the viewer at ease. These are character decisions that may have fallen flat had the film's editing not been adapted to accommodate their role within the narrative.

Editing helps transform these characters, humble and forgotten about within the world they inhabit, by devoting entire prolonged sequences to them, as well as returning to them after almost every scene in acts one and two. By cutting to the droids as they wait outside the Cantina in Mos Eisley, warily eyeing up the gathered Imperial forces, we develop a sense that their opinions matter, that they should be paid attention to. This concept was inspired by the use of the two peasant characters, Tahei and Matashichi, in Akira Kurosawa's *Hidden Fortress* (1958)[58], who are seen as unimportant within the society of the film, but yet are the focal point for how the audience experiences it.

The droids function much like a Greek chorus in mythology, commenting on the action, observing rather than participating, and Hirsch's editing in the opening sequences gives them the time and attention required to prevent the fact that they're essentially expressionless robots from being jarring.

It is particularly pertinent that when it was decided that a scene had to be cut from the first act, Hirsch chose to cut one which strengthened Luke's backstory, where he finds out that his friend is joining the rebellion, rather than cut down the long sequence of the droids arguing alone in the desert. This scene does very little in terms of narrative, and on the surface it would make more sense to instead learn more about the film's central character and his motivations. However Hirsch instead prioritises the droids' relationship, understanding how important the viewer's connection with them is to the film's structure as well as its subtext.

Lucas viewed the droids as key to his Cold War message[59], cultivating the idea that seemingly 'disposable' civilians can have a huge impact if they have the right spirit[60], that they can take down the seemingly all powerful evil Empire.

Interestingly, C3PO's character as it appears in the film was very much a work of editing construction. R2D2 originally had multiple lines of dialogue where he complains and chastises his counterpart, but in post-production they were replaced with his now synonymous beeps and whistles, meaning that C3PO's once understandable reactions become amusing, with him angrily rambling at R2 for no apparent reason[61]. This is an excellent example of a different type of editing, one which has little to do with physical cutting, but where the editor can still make powerful decisions that may change the entire meaning of a film.

The use of reaction shots is another important way in which editors maintain dramatic focus, emphasising the importance of certain characters and their perspective on the action. This is particularly pertinent with Luke, as even though he's the film's central protagonist, and will go on to play an important role in the story's outcome, initially he is more of a bystander; observing action rather than participating in it.

The scene in Obi-Wan's hut is an excellent example of how his reactions are used to keep him positioned as the focal point of the film. Hirsch cuts back to him a total of fourteen times, showing the audience his response to everything that's being said. As a result, Luke's feelings about the information that's being divulged implicitly become just as important to the viewer as the information itself. This both prevents the audience from being overwhelmed and confused by the rather vague explanation of 'the force', and keeps us focused on the film's central character. This despite Alec Guinness having the vast majority of the dialogue, and being a far more established and renowned actor than Mark Hamill at the time.

Editor as Screenwriter

A key, if unheralded job of the editor is to solve a varying number of inevitable script issues, both for reasons of narrative and pacing. The importance of this role has of course increased exponentially today, with studios preferring to shoot things from all possible angles and defer creative decisions to the cutting room as much as possible. Many changes that Hirsch made to this end have been documented, and one would suspect there were many more that are not public knowledge.

Upon replacing Jympson as lead editor Hirsch immediately cut two scenes of Luke's backstory completely, where he explains how he dreams of leaving Tatooine and becoming a pilot for the rebellion. This had the effect of initially leaving the audience less clear about Luke's personality and motivations, as we are never allowed to see him in his natural environment. He therefore became a mysterious and less typical leading man, increasing the aura of intrigue around his character and where he came from.

Countless lines of dialogue were also cut, such as Biggs telling Luke that they're "a couple of shooting stars that can't be stopped" or his uncle shouting "where's he loafed off to now!". These choices were made both for time and for tone, with several pieces of dialogue not fitting with the atmosphere and vernacular of the rest of the script. Through these choices Hirsch manages to create a consistency of style that falls off in certain areas of the original screenplay[62].

Scene 51, where Tarkin and Darth Vadar are informed that they're approaching the rebel base and the thirty minute countdown first appears, was entirely constructed by the editorial department. Close inspection reveals that the scene is composed entirely of a single shot taken from earlier in the film (when Tarkin is informed of the Millennium Falcon's arrival) and the voice on the phone has simply been dubbed over with fresh information.

This becomes a key scene both in terms of rhythm and narrative; it's what begins the ticking clock, Hirsch's train racing down the tracks, that creates the tension and excitement of the climax, introducing the device to the audience. This deadline was never explicitly set up in the shooting script, but its impact is ultimately crucial in the construction of the scene, and becomes a critical piece of narrative structuring, one created entirely in the cutting-room.

The ordering of the entire battle sequence was also reworked for more emotional impact. In the script the battle is fairly evenly matched, with the rebels and Empire firing back and forth, neither side having the edge over the other. However Hirsch reconstructed the sequence so as that initially the rebels appear to have the upper hand, catching the Empire off guard. Then midway through the battle the impetus turns drastically, and a series of important victories for the Empire destroys the vast majority of the rebel fleet. In continuous action the Imperial fighters arrive, Vadar is shown to be joining the attack, Porkins dies and Luke gets hit, followed by the death of two more rebels. Meanwhile the countdown to the rebel base being in firing range has gone down to two minutes. This compounding of difficulties and apparent despair for the rebels sets up a much more exciting and engaging finale. By the end Luke has not simply destroyed the Death Star, he has done so against all conceivable odds, when we had all but lost hope of a possible victory.

In addition, one of the most famous moments in the film is entirely a construct of editing. With victory assured, Obi-Wan famously speaks to Luke from beyond the grave, saying "Remember, the force will be with you, always". This acts as a symbolic sign off to the audience and a reaffirmation of the film's core themes, a reminder of how Luke was able to accomplish such an unlikely feat. However this line was never intended or recorded, and Alec

Guinness had made himself unavailable for any additional dialogue recording. The line is in fact a composited repetition of three snippets: "remember", "the force will be with you" and "always" taken from various sentences in earlier scenes[63].

These examples show just how creative and dynamic editing can be, often going beyond the realm of physical cutting, as Hirsch reworks pieces of seemingly unconnected material, infusing them with new and powerful meaning.

Editing as Style

As Hirsch himself suggests, "An analysis of an editor's work would undoubtedly lead simply to the conclusion that editing style is an extremely difficult term to define" [64]. Of course editors have their own preferences, and elements may be repeated across their body of work, but overall their job is to create a style that is in tune with the rest of the piece, that both matches and adds to the narrative.

Put simply, the editor must bring out the film's style through their cutting, not attach their own onto the film. It is perhaps inevitable though that certain personal propensities will seep through, with Karen Pearlman coyly advising "it's a good idea to know your editor before hiring them" [65].

This is perhaps why certain directors and editors, having found that their tastes are in harmony, will collaborate again and again, such as Quentin Tarantino and Sally Menke, or Martin Scorsese and Thelma Schoonmaker.

Star Wars is an interesting case study in this regard. Hirsch on several occasions openly discusses his distaste for editing that

attempts to attract the audience's attention[66]. These methods, he says, may often succeed in giving the audience more information, but "you don't feel anything"; the cut becomes the event rather than the action it crosses[67]. *Star Wars* though is notable in its style precisely because of just these types of flair techniques, in particular the use of soft-wipe transitions and the famous opening-scroll. Each of these elements certainly fall into the category of creating 'events' out of the edits in question, a visual statement in and of themselves.

It is perhaps ironic then, that Hirsch received such accolades for his artistic achievement with the film, most notably the 1977 Best Editing Oscar, given that his personal sensibilities appear to point in another direction. This is not to say that Hirsch was overruled by George Lucas or anyone else, and there is no evidence to suggest that he was simply carrying out someone else's instructions. No, the film itself, its narrative, tone and style pushed towards this more showy approach to cutting. Hirsch therefore, being a vastly experienced and competent editor, spliced in such a way as to bring out these elements, and the film benefits as a result.

It cannot be said of course that these elements of style are unique to *Star Wars* alone, although they did introduce them to a new generation of cinema goers[68]. The key influences of *Star Wars* are well established, most notably *Flash Gordon Conquers the Universe* (1940, prod. Universal Pictures), westerns such as *The Searchers* (1956, dir. John Ford) and *The Good, The Bad and The*

Ugly (1966, dir. Sergio Leone)[69] as well as the films of Akira Kurosawa.

Much of the more visual stylistic decisions in the film stem from these works, and the same can be said for how it is out. Hirsch uses these references to help create the feel of a children's cartoon, enthused with the excitement and danger of a Western.

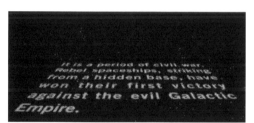

Star Wars Opening Crawl (1977)

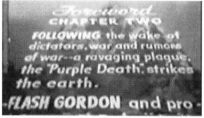

Flash Gordon Opening Crawl (1940)

The opening crawl is a particularly showy piece of style, as the text flies back across the stars. This has now become entirely synonymous with *Star Wars* but was in fact a direct homage to the *Flash Gordon* serialised cartoons. This, along with the famous "a long time ago, in a galaxy far, far away…" tagline which open the film, immediately sets up a larger than life kind of playful atmosphere.

The scroll also performs an absolutely fundamental narrative purpose, which is perhaps why Lucas accepted a hefty fine in order to use it in place of a more traditional credits sequence, resigning

both from the Directors' Guild and the Motion Picture Association as a result[70]. The scroll introduces the audience to the world and its fundamental plot points, to a great extent eliminating the need for excessive backstory and explanations throughout the rest of the film. It functions almost as a framing device for the plot, explaining everything the audience needs to know in terms of narrative, atmosphere and tone, thus conversely adding to the realism of the remainder of the work.

Somewhat surprisingly, realism and a documentary type of approach are a central element of all areas of *Star Wars'* production[71]. Lucas was a passionate fan of cinema verité, and he brought many of these aesthetics to the film, at least initially.

This is most apparent through the *in media res* immersion into the many foreign environments and cultures that make up the film's universe[72]. Hirsch allows himself to enter scenes long after they've begun, often midway through a conversation that the audience knows nothing about, leaving us to fill in the gaps.

The opening battle sequence is perhaps the most famous example of this, with C3PO shrieking "did you hear that? They've shut down the main reactor! There'll be no escape for the princess this time!", with no hint at how it is that these robots can talk, who the princess is, or who their attackers are. Hirsch and Lucas gambled, with great success, that the audience would accept and go along with this extreme disorientation, understanding that they

weren't required to follow the intricacies of precisely what was going on; "we understand the general meaning", he says, "if not the detail" [73].

This has the effect of making the film feel far more kinetic and fast moving, and this element of realism was much needed in order for the viewer to buy into the world and its characters, whose effects and prosthetics, while impressive, are far from being entirely convincing. This is an extremely difficult balancing act, trying to invoke the audience's imaginations as they attempt to construct a reality around these mere glimpses, while not frustrating them through failure to provide enough information. The film's enduring and passionate following is testament to just how right Lucas and Hirsch got this balance [74].

It is this sense that there is an entire world to discover within the background of the film that has created such a cult and mythology around the series, with hundreds of novels and fan-sites devoted to filling out these backstories (the *Star Wars* specific Wikipedia has over 87,000 separate pages [75]).

It should though be noted that far more of this documentary style was originally intended than that which eventually made the final cut. Lucas appeared a bigger proponent of this form in theory, with the film shot in a series of long and unintrusive master shots with improvised dialogue, than in practice. He subsequently veered the editors towards a much quicker and more constructed pace when

it came to cutting. Here again, editing marked a move away from the preferred style of the artists towards a tone more fitting with the material.

The firing and subsequent replacement of the film's original editor, John Jympson, is seen by many as the turning point in this regard. Hirsch and his crew were instructed to take Jympson's cut, which conformed to this style of long neutral Bazinian takes of unfolding action, and create a far more lively and proactive version[76].

The use of soft-wipes was another brave visual choice made in post-production. This again was a deliberate decision to recall the serial cartoons of Lucas's youth[77], as well as serving as another reference to the works of Akira Kurosawa. The functions of these transitions are twofold; on one level they serve an obvious, if inessential, narrative purpose, with different types being used to emphasise aspects of setting, time and/or production design.

img.1

img.2

img.3

The wipe in img.1 leaves the desert shots almost falling into each other, adding to a sense of vast emptiness. The clock-wipe of img.2 clearly adds to the sense of time passing, and the circle wipe used in img.3 focuses our attention on the vehicle carrying the droids.

However, they also serve a more interesting and implicit emotive purpose. The transitions help contribute to the showmanship of the film, the feeling of an exciting and fun story. While Hirsch discusses this type of technique as being used to divulge information rather than to evoke feeling, in this case feeling is precisely what they're used for. They evoke the sense of these old cartoons, particularly for *Star Wars's* contemporary audience who would have been well acquainted with them[78], so that they may then take the sense of play they associate with the source material and displace it onto the film.

These 'intertextual frames' are scattered throughout, most notably through the use of these types of effects. as well as within the mythological archetypes that so many of the characters embody (Luke as the reluctant hero, the droids the Greek chorus, Leia the damsel in distress etc[79]). These references induce a deep kind of reactionary pleasure, one which Umberto Eco aptly describes as "an intense emotion [...] a vague feeling of déjà vu that everybody yearns to feel again" [80].

Similarly to how *Chinatown* (1974, dir. Roman Polanski) recaptures the feeling of the 1930s, or *Brick* (2005, dir. Rian Johnson) the atmosphere of classic film noir, rather than satirising these pieces of reference material *Star Wars* allows the audience to relive them in a new setting. While a younger viewer will gain great pleasure from being exposed to these elements of character and style for the first time, a contemporary adult audience was able to fulfill their nostalgic desire to revisit the stories of their youth[81], the type of which had long since stopped being made.

Similarly, Hirsch was also not afraid to heavily incorporate cutting patterns that were referential of other films. In order to give the tie-fighter dogfight a more realistic feel for instance, it was decided that they would mimic World War Two documentaries, with the shot compositions and cut points almost identical to the source material[82] they were adapted from.

In addition, the editing of Han Solo's famous confrontation with Greedo in the Cantina is noticeably similar to the bar shoot-out in *The Good The Bad and the Ugly*, with its very sharp and dramatic cutting style. This further emphasises the western aesthetic that Lucas was so fond of, and implicitly draws the comparison between Mos Eisley and the archetypal taverns full of outlaws this genre was so famous for, where just like in *Star Wars*, nobody cares if you shoot someone under the table, as long as you don't make a mess[83].

In both these cases, Hirsch forgoes the editing style and rhythms of the rest of the film in order to refer to these pieces of source material. Here editing is used to create atmosphere, not just through the cuts in themselves but through the famous pieces of cinematic vocabulary which they mimic. The editing style implicitly reminds the audience of the mood of those films, and provides a kind of grounding for the action that is taking place and how it should be interpreted. Mos Eisley stops being a strange and foreign place that the viewer has no connection with; it becomes perfectly clear just what kind of town we're in.

The showmanship of these moments of editing, where 'signs of construction' are left visible for all to see, represented a significant shift in style from both the films of the time and other works within the science fiction genre. Due to a combination of circumstances, Hollywood had recently undergone a sharp shift in focus, with realism, anti-heroes and fresh perspectives rising to the fore in the period that later became known as the Post-Classical/New Hollywood Era[84].

The socio-political context was also particularly bleak, with the United States in the midst of the Vietnam War. All this was reflected in cinemas, with downbeat and gritty films such as *Easy Rider* (1969, dir. Dennis Hopper), *Taxi-Driver* (1976, dir. Martin Scorsese) *Chinatown* (1974, dir. Roman Polanski) and *The Godfather* (1972, dir. Francis Ford Coppola). Editing tended to

reflect this style; this was notably around the time that the dissolve stopped being a staple of mainstream film.

In addition, while science fiction films tended to represent aliens as the enemy, something to fear and run from, such as in *Invasion of The Body Snatchers* (1956, dir. Don Siegel), *War of The Worlds* (1953, dir. Byron Haskin), and *Alien* (1979, dir. Ridley Scott), *Star Wars* creates a universe full of creatures with rich and diverse personalities. While these films tended to hold the extra-terrestrials in the background, creeping around shadowy corners for shock value, *Star Wars* pushes them to the fore. Much of the charm of the film is associated with exploring all the different types of creatures our heroes encounter.

The film went on to have a significant impact in reorienting the output of Hollywood in the period following its release. *Star Wars* heralded a shift away from the seriously themed dramas towards more light-hearted blockbusters. This was the beginning of the end of the post-classical era and the birth of the age of the blockbuster, where studios spend vast amounts of money on films that can become part of a 'franchise'. It also very much brought computer generated imagery (CGI) to the mainstream, a process that up to that point hadn't been particularly popular or well explored.

It is perhaps ironic that it was the original Star Wars film that began the trend of relying so heavily on visual effects, something for which *Star Wars: The Phantom Menace* was so heavily criticised 25

years later, sacrificing narrative flow to show-off breakthroughs in animation techniques[85].

Conclusions

The influence of editing on *Star Wars* runs powerfully through the film, working on a number of levels. The film is paced and structured to most effectively captivate the audience and affect their emotions, varying between quicker and slower rhythmic patterns to both maximise audience engagement and serve functions of narrative and theme. This is achieved both in individual scenes and across the broader film as a whole. Parallel action emphasises the central conflict between the two sides and exposes their differing perspectives and philosophies, while techniques such as montage and the Kuleshov effect express feelings of grief and peril that cannot be effectively conveyed through acting alone.

Choices of character focus, reaction shots, and the deletion or re-purposing of key scenes clarify the story and its message. Brave elements of style are invented and others borrowed from reference material to create and solidify the film's atmosphere and tone, notably helping transport the audience back to the sense of play that embodied westerns and 1950s cartoons, reinventing them for a new era. Meanwhile, elements of a cinema verité approach are

emphasised when suitable for the story, and successfully worked around when not.

Ultimately, everything *Star Wars* is most remembered for its fast paced and engaging story, the sense of glimpsing just the surface of a rich and exciting universe, its sympathetic protagonists and devious villains, its classical narrative of good versus evil[86], are all emphasised and cemented by creative editing decisions. Perhaps the slightly complicated position editing holds both within the film industry and in the eyes of the general public is due in part to this vast breadth of influence, making it hard to easily single out and identify.

However, this focused analysis, as well as exploring the intricacies of how editing works within a specific piece, hints at some broader conclusions as regards the craft as a whole. Decisions in every regard are uniformly based on the needs of story, how it can be presented in the most engaging and entertaining way possible. This key requirement should overrule the personal tastes both of the editor and the director, as it did in *Star Wars* on several occasions. The importance of a varied rhythm has also been emphasised as a critical element in the satisfactory telling of the story, and this pattern should be created with both narrative and thematic considerations in mind.

There remains an implied distinction between 'craft' and 'creative' editing[87], supported in the writings of Eisenstein and Pudovkin[88], with certain cuts made to generate impressions but others apparently to simply move the story forward. Closer inspection however reveals a more complex entanglement of these two ideas. Every editing decision, no matter how apparently simple, has been chosen over the almost infinite amount of other options available at any given time. Each of these choices, if made correctly, is done with regard to best supporting the underlying story, emotion, rhythm and tone and the slightest of differences, often the size of a single frame, can have surprisingly powerful effects[89].

With the vast complexity of these decisions, ones which must work on so many different levels and with so many available options, it is unsurprising that editors speak highly of their intuition as the determining factor[90] in how they decide which path to take.

Ultimately the single point that this analysis articulates most clearly is that contrary to popular belief editing is by no means 'invisible'. The audience may not see the cuts themselves, but they see movement of story, of emotion, of images and sound; all of this has been shaped by an editor[91]. The process of then observing and analysing the technique that has gone into these decisions is not part of the audience's experience, but it is nevertheless perfectly feasible and rewarding, with good editing decisions rising quickly to the

conscientious viewer's attention. Editing may well remain cinema's secret magic trick[92], but its effects do not go unnoticed.

Notes

1 Murch, Walter. *In the Blink of an Eye* (Silman-James Press, 1995) p.10

2 Gottlieb, Sidney, *Alfred Hitchcock: Interviews* (University Press of Mississippi, 2003) p.100

3 Kubrick, Stanley and Philips, Gene, *Stanley Kubrick: Interviews* (University

4 Welles, Orson, speaking in *Filming Orthello* (1978, dir. Orson Welles)

5 Ibid

6 Murch, op.cit., p.18

7 Dmytryk, Edward, *On Film Editing* (Focal Press, 1984) pp.23-145

8 The discussion will be based entirely on an analysis of the original 1977 theatrical release edition, subsequently made available in the 2006 DVD re-release, not on any of the subsequent "digitally re-mastered" versions.

9 Ebert, Roger, *Star Wars (Episode IV: A New Hope) Review* (1999, www.rogerebert.com)

10 sourced January 2011 from Box Office Mojo: http://boxofficemojo.com/alltime/adjusted.htm

11 *The Force is With Them: The Legacy of Star Wars* (2004, dir. Gary Leva)

12 Brooker, Will, *Star Wars (BFI Film Classics)* (British Film Institute, 2009) p.51

13 Grace, Francie, *People's Choice: Star Wars* (2006, CBS News) retrieved October 2010 from: http://www.cbsnews.com/stories/2006/01/11/entertainment/main1201116.shtml

14 Hirsch, Paul interviewed in Pellegrom, Dennis, *Paul Hirsch - Editor - Star Wars* (2010, 'Star Wars Interviews') retrieved November 2010 from: http://starwarsinterviews1.blogspot.com/2010/07/paul-hirsch-editor-star-wars.html

15 This is around average by today's standards, but was relatively high in 1977.

16 Pearlman, Karen *Cutting Rhythms: Shaping The Film Edit* (Focal Press,200) *p.X* (preface)

17 Oldham, Gabriella, *First Cut: Conversations with Film Editors* (University of California Press, 1995) p.381

18 Ibid., p.297

19 Pearlman (1995) op.cit., p.79

20 Bordwell, David and

Thompson, Kristin, *Film Art: An Introduction* (McGraw-Hill Education, 1996) p.258
21 Hirsch, Paul quoted in Kelley, William *A Conversation with Editor Paul Hirsch* (2005, From Script to DVD), retrieved May 2010 from: http:// www.frontscripttodvd.com /paul_hirsch_interview.html
22 Ibid.
23 Chew, Richard, speaking in *Star Wars: Behind The Magic* (1998, prod. LucasArts)
24 Bordwell and Thompson op.cit., pp.182-193
25 Bartenieff, Laban with Lewis, Dori, quoted in Pearlman op.cit., p.59
26 Bordwell, David, *Narration in the Fiction Film* (Routledge, 1987) p.249
27 Bordwell and Thompson op.cit., p.258
28 Cruz, Nicasio, *The Art of Editing* (2001, Ateneo de Davao University) retrieved December 2010 from: http:// www.angelfire.com/film/eliab/ artofediting.html
29 Eisenstein, Sergei, *Film Form: Essays in Film Theory* (Harcourt, 1960) p.75
30 Reisz, Karel and Millar

Gavin, *The Technique of Film Editing* (Focal Press, 2009) p.21
31 Bordwell, David, *My Name is David and I'm a Frame-Counter* (2007, 'David's Bordwell's Website on Cinema')
32 Brooker op.cit., p.20
33 Bordwell, David (1987) op.cit., p.249
34 Pearlman, Karen speaking in *Timing and Gestures* (2010, Screen Studies) retrieved January 2011 from: http://blip.tv/file/ 4381892
35 Gilchrist, Garrett in *Star Wars: Deleted Magic* (2005, dir. Garrett Gilchrist)
36 Oldham op.crit., p.194
37 Bordwell, David (1987) op.cit.
38 Stoklasa, Mike, *Star Wars: Episode 1 Review* (2005, Red Letter Media) (video) retrieved September 2010 from http:// www.redlettermedia.com/ phantom_menace.html
39 Nichols, Mike in *Star Wars: Episode I - The Phantom Edit* (2001, dir. Mike J. Nichols)
40 Stoklasa, Mike op.cit.
41 Ciment, Michel, *Kubrick: The Definitive Edition* (Faber & Faber, 2003) p.41
42 Pudovkin, Vsevolod *On Editing*, in Mast, Gerald et al., *Film Theory and Criticism:*

Introductory Reading
(Oxford University Press,
1985) p.121
43 Pudovkin op.cit p.125
44 Brooker op.cit. p.77
45 Eisenstein op.cit p.245
46 Aumont, Jacques
Aesthetics of Film
(University of Texas Press,
1992) p.54
47 Nelmes, Jill, *An
Introduction to Film Studies*
(Routledge, 2003) p.399
48 Rinzler, J.W, *The Making
of Star Wars: The Definitive
Story Behind The Original
Film* (Ebury Press, 2007) p.
219
49 Ibid.p.149
50 Knight, Arthur, *The
Liveliest Art; A Panoramic
History of the Movies*
(Macmillan, 1978) p.80
51 Godard, Jean Luc,
quoted in Bordwell (1987)
op.cit p.327
52 Oldham op.cit p.193
53 Gilchrist op.cit
54 Prince, Stephen *The
Expressive Function of
Editing* (2003,
filmreference.com) retrieved
September 2010 from:
filmreference.com/
encyclopedia/Criticism-
Ideology/Editing-the-expressive-
functions-of-editing.html
55 Pudovkin op.cit , p.122.
56 Young, Jonathan speaking in
*The Force is With Them: The
Legacy of Star Wars* (2004, dir.
Gary Leva)
57 Brooker op.cit p.24
58 Brooker op.cit p.53
59 Gingrich, Newt, speaking in
*The Force is With Them: The
Legacy of Star Wars* (2004, dir.
Gary Leva)
60 Murch, Walter speaking in
Ondaatje, Michael, *The
Conversations: Walter Murch and
the Art of Editing Film* (Random
House, 2002) p.70
61 Guenette, Robert in *The
Making of Star Wars* (1977, dir.
Robert Guenette)
62 screenplay sourced January
2011 from Screenplays-Online:
http://www.screenplays-online.de/
screenplay/66
63 Gilchrist op.cit.
64 Oldham op.cit. p.195
65 Pearlman op.cit. (2010 -
Timing and Gestures)
66 Oldham op.cit. p.189
67 Kelley, William op.cit.
68 Silverman, Steve *Life After
Darth* (Wired Magazine, 13th of
May 2005)
69 Jenkins, Garry, *Empire*

5

Building: the remarkable,
Real-life Story of "Star
Wars" (Simon & Schuster
1998) p.170
70 Burns, Kevin in *Star
Wars: Empire of Dreams*
(2004, dir. Edith Becker &
Kevin Burns)
71 Brooker op.cit. p.39
72 Ibid p.20
73 Ibid pp.37-38
74 Ibid. p.33
75 Wookipedia, sourced
October 2011 from
www.wookipedia.org
76 Brooker op.cit. p.63
77 Brennan, Kristen, *Star
Wars Origins - Flash Gordon*
(1997, Star Wars Origins)
retrieved December 2010
from: http://moongadget.com/
origins/flash.html
78 Jameson, Fredric,
*Postmodernism and
Consumer Society* (1998, The
Cultural turn)
79 Dr. Lyden, John speaking
in *The Force is With Them:
The Legacy of Star Wars*
(2004, dir. Gary Leva)
80 Eco, Umberto quoted in
Brooker op.cit. p.29
81 Jameson, Fredric op.cit.
82 LucasArts in *Star Wars:
Empire of Dreams* (2004, dir.

82 LucasArts in *Star Wars:
Empire of Dreams* (2004, dir.
Edith Becker & Kevin Burns)
83 Dr. Lyden op.cit.
84 Cook, David A., *Lost Illusions:
American Cinema in the Shadow
of Watergate and Vietnam,
1970-1979*, (History of the
American Cinema) (2002,
University of California Press) p.
67
85 Stoklasa, Mike op.cit.
86 Leva, Gary op.cit.
87 Murch (1995) op.cit p.10
88 Knight, Arthur op.cit
89 Pearlman (2010 - *What is
Rhythm*) op.cit
90 Oldham op.cit. p.381
91 Pearlman, Karen *Editing is not
invisible but it is magic* (2010,
Screen Studies) (video)
retrieved January 2011 from
http://blip.tv/file/4381878
92 Ibid

Bibliography

Aumont, Jacques, *Aesthetics of Film* (University of Texaz Press, 1992)

Bazin, André, *What is Cinema?, Volume 1* (University of California Press, 2004)

Bordwell, David, *Narration in the Fiction Film* (Routledge, 1987)

Brooker, Will, *Star Wars* (British Film Institute, 2009)

Brooker, Will, *Using the Force: Creativity, Community and Star Wars Fans* (Continuum, 2003)

Ciment, Michel, *Kubrick: The Definitive Edition* (Faber & Faber, 2003)

Cook, David, *Lost Illusions: American Cinema in the Shadow of Watergate and Vietnam 1970-1979* (University of California, 2002)

Dancyger, Ken, *The Technique of Film and Video Editing: History, Theory and Practice* (Focal Press, 1984)

Dmytryk, Edward, *On Film Editing* (Focal Press, 1984)

Eisenstein, Sergei, *Film Form: Essays in Film Theory* (Harcourt, 1969)

Gottlieb, Sidney, *Alfred Form: Essays in Film Theory* (Harcourt, 1969)

Gottlieb, Sidney, *Alfred Hitchcock: Interviews* (University Press of Mississippi, 2003)

Jenkins, Garry, *Empire Building: Remarkable, Real-life Story of "Star Wars"* (Simon & Schuster, 1998)

Kaminski, Michael, *The Secret History of Star Wars* (Legacy Books Press, 2008)

Knight, Arthur, *The Liveliest Art: A Panoramic History of the Movies* (Macmillan, 1978)

Kubrick, Stanley and Gene Phillips, *Stanley Kubrick: Interviews* (University Press of Mississippi, 2001)

Mast, Gerald et al., *Film Theory and Criticism: Introductory Reading* (Oxford University Press, 1985)

Murch, Walter, *In The Blink of an Eye* (Silman-James Press, 1995)

Nelmes, Jill, *An Introduction to Film Studies* (Routledge, 2003)

Oldham, Gabriella, *First Cut: Conversations with Film Editors* (University of California Press, 1995)

Ondaatje, Michael, *The Conversations: Walter Murch and the Art of Editing Film* (Random

House, 2002)
Pearlman, Karen, *Cutting Rhythms: Shaping The Film Edit* (Focal Press, 2009)
Reisz, Karell and Gavin Millar, *The Technique of Film Editing* (Focal Press, 2009)
Rinzler, J.W, *The Making of Star Wars: The Definitive Story Behind The Original Film* (Ebury Press, 2007)
Silberman, Steve *Life After Darth* (Wired, May 2005)

Electronic Sources

Bordwell, David, My Name is David and I'm a Frame-Counter (2007, David Bordwell's Website on Cinema) retrieved September 2010 from http://www.davidbordwell.net/blog/?p=230

Brennan, Kristen, *Star Wars Origins - Flash Gordon* (1997, Star Wars Origins) retrieved December 2010 from: http://moongadget.com/origins/flash.html

Cruz, Nicasio, *The Art of Editing* (2001, Ateneo de Davao University) retrieved December 2010 from: http://www.angelfire.com/film/eliab/artofediting.html

Ebert, Roger, 'Star Wars (Episode IV: A New Hope)' (1999, Rogerebert.com) retrieved November 2010 from: http://bit.ly/ibriVd

Grace, Francie, *People's Choice: Star Wars* (2006, CBS NEWS) retrieved October 2010 from: http://bit.ly/7Y4Rfc

Jameson, Fredric, *Postmodernism and Consumer Society* (1998, Consumer Society (1998, The Cultural Turn) retrieved January 2010 from: http://bit.ly/9JSnR5

Kelley, William, *A Conversation With Editor Paul Hirsch* (2005, From Script To DVD) retrieved November 2010 from: http://www.fromscripttodvd.com/paul_hirsch_interview.htm

LucasFilm, *Anatomy of a Dewback* (1997, StarWars.com) retrieved November 2010: http://www.starwars.com/episode-iv/bts/article/f19970811/index.html?

Lucas, George, *Star Wars: A New Hope Screenplay, Revised Fourth Draft* (2004, Screenplays Online) retrieved January 2011 from: http://www.screenplays-online.de/screenplay/66

Pearlman, Karen, *Timing and Gesture* (2010, Screen Studies) (video) retrieved January 2011 from: http://blip.tv/file/4381892

Pearlman, Karen, *What is Rhythm* (2010, Screen Studies) (video) retrieved January 2011 from: http://blip.tv/file/4381895

Pearlman, Karen, *Editing is not invisible but it is magic* (2010, Screen Studies) (video) retrieved January 2011 from: http://blip.tv/file/4381878

Pellegrom, Dennis and Paul Hirsch, *Paul Hirsch - Editor -*

Star Wars (interview) (2010, 'Star Wars Interviews') retrieved November 2010, Prince, Stephen, *The Expressive Function of Editing* (2002, filmreference.com) retrieved September 2010 from: filmreference.com/encyclopedia/Criticism-Ideology/Editing-THE-EXPRESSIVE-FUNCTIONS-OF-EDITING.html

Stoklasa, Mike, *Star Wars: Episode 1 Review* (2005, Red Letter Media) (video) retrieved September 2010 from http://www.redlettermedia.com/phantom_menace.html

Filmography

2001: A Space Odyssey (1968, Stanley Kubrick)

21 Grams (2003, dir. Alejandro Gonzalez Inarritu)

A Bout de Souffle (1960, dir. Jean-Luc Godard)

Alien (1979, dir. Ridley Scott)

American Graffiti (1973, dir. George Lucas)

The Bourne Supremacy (2004, dir. Paul Greengrass)

Brick (2005, dir. Rian Johnson)

Chinatown (1974, dir. Roman Polanski)

Close Encounters of the Third Kind (1977, dir. Steven Spielberg)

Citizen Kane (1941, dir. Orson Welles)

The Cutting Edge: The Magic of Movie Editing (2004, dir. Wendy Apple)

Dr. Strangelove or: How I learned to Stop Worrying and Love the Bomb (1964, dir. Stanley Kubrick)

Easy Rider (1969, dir. Dennis Hopper)

Filming Othello (1978, dir. Orson Welles)

Flash Gordon Conquers the Universe (1940, dir. Ford Beebe)

The Force is With Them: The Legacy of Star Wars (2004, dir. Gary Leva)

Forrest Gump (1994, dir. Robert Zemeckis)

The Godfather (1972, dir. Francis Ford Coppola)

Gone With the Wind (1939, dir. Victor Fleming)

The Good, The Bad and the Ugly (1966, dir. Sergio Leone)

Hidden Fortress (1958, dir. Akira Kurosawa)

Intolerance (1916, dir. D.W. Griffith)

Invasion of The Body Snatchers (1956, dir. Don Siegel)

Lord of The Rings: The Two Towers (2002, dir. Peter Jackson)

The Making of Star Wars (1977, dir. Robert Guenette)

Memento (2000, dir. Christopher Nolan)

The Mythology of Star Wars (2000, dir. Pamela Mason Wagner)

The Searchers (1956, dir. John Ford)

Seven Samurai (1954, Akira Kurosawa)

Star Wars (1977, dir. George Lucas)

Star Wars: Behind The Magic (1998, LucasArts)

Star Wars: Deleted Magic (2005, dir. Garrett Gilchrist)

Star Wars: Episode I - The Phantom Edit (2001, dir. Mike J. Nichols)

Star Wars: Episode I - The Phantom Menace (1999, dir. George Lucas)
Star Wars: Episode II - Attack of the Clones (2002, dir. George Lucas)
Star Wars: Episode III: Revenge of the Sith (2005, dir. George Lucas)
Star Wars: Episode V: The Empire Strikes Back (1980, dir. Irvin Kershner)
Star Wars: Episode VI: Return of the Jedi (1983, dir. Richard Marquand)
Star Wars: Empire of Dreams (2004, dir. Edith Becker & Kevin Burns)
Star Wars: The Magic & the Mystery (1997, dir. Thomas C. Grane)
Taxi Driver (1976, dir. Martin Scorsese)
THX 1138 (1971, dir. George Lucas)
War of The Worlds (1953, dir. Byron Haskin)

15895240R00048